James Richards
To Replace a Minute's Silence with a Minute's Applause

James Richards

To Replace a Minute's Silence with a Minute's Applause

Whitechapel Gallery v———— a – c

Contents

Sponsor's foreword

We are delighted to continue our support of the Whitechapel Gallery's programme of collection displays. This collaboration with the V-A-C Foundation is testament to the Whitechapel Gallery's reputation as one of the world's most innovative and ambitious public galleries.

Hiscox is proud to have sponsored the Whitechapel Gallery's Displays Programme since the series began in 2009. We are looking forward to the final display of what has been an enlightening exploration of the V-A-C collection.

Robert Hiscox, *Hon. President, Hiscox Insurance*

Collector's foreword

The four-part presentation of works from the V-A-C collection at
the Whitechapel Gallery concludes with *To Replace a Minute's Silence
with a Minute's Applause* by James Richards, who decided to focus
solely on one work, Francis Bacon's *Study for a Portrait* (1953). This is
presented in an aural environment that sees Richards constituting a
new set of meanings and experiences that are as concerned with the
past as the present. Just like this final display, the V-A-C collection
has been seeking to look through the prism of the past into the
future, starting from the most innovative works by Constantine
Brancusi or Andy Warhol and bringing them into dialogue with
those by Olivier Mosset or Wade Guyton.

On behalf of the whole V-A-C Foundation team, I would like
to express my most sincere thanks to Iwona Blazwick for giving
us this opportunity to show for the very first time works from the
collection and for providing the much needed support in this major
stepping stone for V-A-C, to work with such an established and
visionary institution. I would like to express my gratitude to the
wonderful staff at the Whitechapel Gallery including Curator Omar
Kholeif and former Chief Curator Magnus af Petersens for their
insightfulness and devotion to art. They precisely understood the
collection's aspirations and its role for the Foundation.

This is the first time that works from the V-A-C collection
have been shown outside of Russia. During this momentous
period of time, it has been important to establish the collection's
increasing openness to the international art community and to art's
ever changing history. Francis Bacon was one of the most radical
and influential artists of his time and the Foundation is honored
to possess one of his works, in this case, one of the last major

paintings produced in his studio at the Royal College of Art in London. We bow to the talent of this master.

I would like to thank James Richards for creating this final display. Sieving the visual intensity of Francis Bacon's portrait, he presents a new installation that is a work of art in its own right. Richards suspends time for the viewer and gives us a chance to see something familiar from a different perspective; it is an inescapable emotional experience.

The ways we look at art have been changing progressively over time: we encounter alternative spaces that move away from the traditional white cube and works that retain their physicality and solidity of form. The four displays at the Whitechapel Gallery were not only art exhibitions but also environments where the works were actors in a play. Here, the curators and the artists demonstrated the collection's strive for future change, the energy that will continue to drive it forward. Under the meticulous and thoughtful direction of Mike Nelson, Fiona Banner, Lynette Yiadom-Boakye and James Richards, the V-A-C collection was given new life; it is a rapidly developing entity with a distinctive spirit that is both young and brave.

Victoria Mikhelson, *V-A-C Foundation*

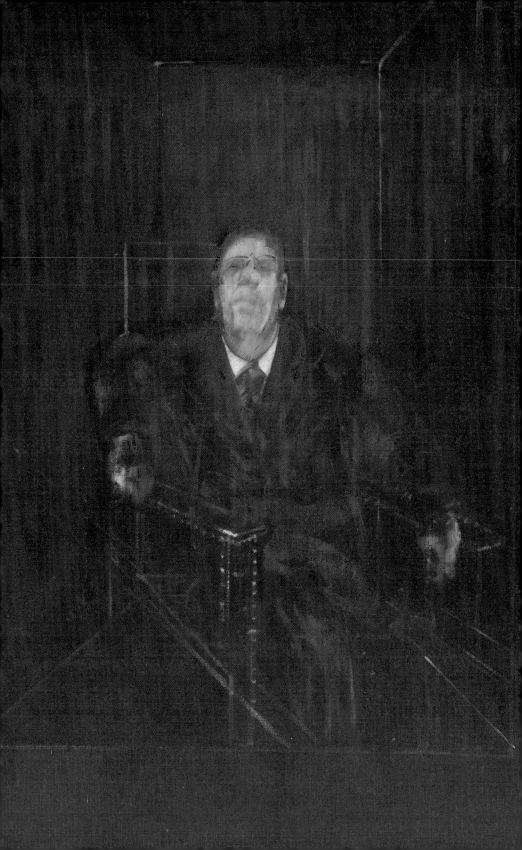

The Sound of Silence

IWONA BLAZWICK

*Great art is always a way of concentrating, reinventing what is called
fact, what we know of our existence... tearing away the veils that fact
acquires through time.* [1]
FRANCIS BACON

A windowless, carpeted room is draped in flesh-coloured curtains.
At one end of the room is a freestanding white wall. On it hangs
a single painting. It pictures another, much darker room, also
occupied by a lone presence. A heavy-set middle-aged man is
seated in a rather grand chair. His charcoal suit and tie, which
almost blend with the streaky ivory black background, identify
him as someone in business, or an establishment figure. Although
he casually balances one leg on the other and his arms rest on the
chair, his head is tilted upwards as if he is listening intently to or
for something. He looks powerful, but vulnerable. The chair is
not fully realised, but a linear schematic etched in flashing lines of
cadmium yellow. The sombre interior in which he sits is rendered
as a simple graphic perspective, a geometric box. The only truly
three-dimensional aspect of this painting is the man's bald head,
luminous white paint evoking a soft spherical mass with fine blue
lines and cavities describing the mouth, nostrils and spectacled
eyes.

Multiple frames magnify the intensity of this portrait; they are
like the sights of a rifle. The chair frames the sitter's body; the black
interior frames the chair; a frame of translucent navy blue hovering
on the outer edges of the painting encloses the space. The painting
itself is gilt-edged in a golden frame. And of course a wall frames the

Francis Bacon
Study for a Portrait 1953 (detail)
Oil on canvas
198 × 137.5 cm

painting, itself framed by the windowless room in the Whitechapel Gallery.

Bacon once remarked, 'I believe in deeply structured chaos.'[2] The structures of containment in his *Study for a Portrait* (1953) intensify the sitter's pale energy. The work is not exactly a portrait. As the French philosopher Gilles Deleuze commented in his study of Bacon, 'Painting has to extract the Figure from the figurative', and 'Thus isolated, the Figure becomes an Image, an Icon.'[3] Chairs are a common feature of Bacon's paintings, their various styles revealing his early training as an interior designer. This chair is more like a pictogram, emblematic – of what? An armchair? A throne? An interrogator's chair? It could be the seat of power or of restraint.

Born in Dublin in 1909, Francis Bacon became Britain's most pre-eminent modernist painter. A contemporary of Abstract Expressionists such as Mark Rothko or Willem de Kooning, he brings abstraction and figuration into an acute synthesis which, like his peers, 'tears away the veils' to reveal a concentrated expression of being. Having consumed the writings of Friedrich Nietzsche in his youth, Bacon made *Study for a Portrait* in the 1950s when the ideas of Jean-Paul Sartre were widely disseminated. This figure could be the poster boy for existentialism. The freedom and responsibility of autonomy and self-determination are edged about by the dark void of being utterly alone. The metaphorical constraint of frame within frame could also describe stunting societal norms, a lived reality for Bacon at a time when homosexuality was illegal.

The palpable sense of imminence in this electrifying painting is made spatial and temporal by the Welsh born artist James Richards (b. 1983) in his display from the V-A-C collection. Richards won a nomination for the 2014 Turner Prize for a remarkable moving image work titled *Rosebud* (2013). This black-and-white assemblage of found and shot footage takes image and sound on separate journeys. The camera lingers on the surface of a puddle, the feathery outlines of wild flowers being drawn across a body, hands slowly rolling across the floor, the etching of an eye on a ten-dollar bill, a parakeet cupped in a hand. The soundtrack blends birdcalls with sirens, jet planes with the ambient sounds of the studio. These moving images are interspersed

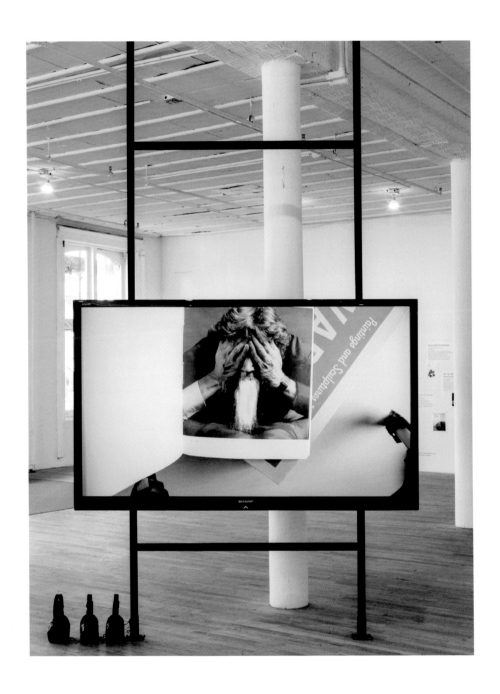

James Richards
Rosebud 2013

Digital video
Installation view from the exhibition
Frozen Lakes, Artists Space, New York, 2013

with stills of photographs from books that were found in a library in Japan, all of which had been defaced. The images, by artists such as Robert Mapplethorpe each featured a penis, every one of which has been meticulously scratched away. The violence of these phantom castrations jars with the elegiac lyricism of the images between them. Coincidentally the scratchy white absence in the centre of each image reminds us of the pallid white figures that twist and contort at the centre of Bacon's dark interiors. Like Bacon, Richards speaks about wanting to treat 'stuff from the world' in a way that is abstract. His sound and music compositions are his way of 'owning, digesting and disorientating' the image.[4]

Given free rein of the V-A-C collection Richards elected to choose just one 'hefty work'. In conceiving the display he considered the theatricality of exhibition making and created a mise-en-scène of drapery, carpeting and subdued lighting. The hushed gallery is reverential and quietly dramatic. Richards has further immersed the painting in a specially composed sonic environment.

A collector of sounds, he layers and overlaps audio tracks weaving together three components. The first element is 'cultural' – speech, songs and melodies. Thinking about Bacon's epoch the artist has included fragments of music like Brenda Lee's 1960s' hit 'I'm Sorry' alongside passages of a sombre piano and violin piece, and a film score to add 'noirish tension'. These associative elements suggest narratives and images; they can momentarily transport us to different historical periods or trigger emotions.

The second component is 'textural' – material sounds such as ringing and clinking, vibrations, cracks and scratches. Softened or amplified, looped and layered Richards's composition gives sound a material, phenomenological presence. Echoing Bacon's painting technique, Richards 'smears' sounds over one another so that they enter the realm of abstraction.

The third component might be described as the sound of silence. In a tribute to sound artist Jonty Semper's 2001 work *Kenotaphion*, an archive recording of two-minute silences in remembrance of Armistice Day, Richards captures the very particular atmosphere of a crowd standing in silence; the ambient

sound of shifting, breathing bodies. This sense of suspension echoes the atmosphere of anticipation that pervades Bacon's *Study for a Portrait.*

Richards has arranged four benches, not in front of, but on either side of the canvas. The portly businessman is transformed from icon to participant. He joins us as an intent listener to the harmonies and dissonances that wrap around us, at once abstract and associative.

1 Francis Bacon quoted in *Francis Bacon: The Papal Portraits of 1953*, Museum of Contemporary Art, San Diego, CA, 1999.
2 Francis Bacon quoted in Robin Blake, 'Francis Bacon's photographic sources', *Financial Times*, 3 April 2010, http://www.ft.com/cms/s/2/0b603a2a-3cf9-11df-bbcf-00144feabdc0.html, accessed 28 June 2015.
3 Gilles Deleuze, *The Logic of Sensation*, Editions du Seuil, 2002, Daniel W. Smith (trans.), Continuum, London, 2003, p.8 and p.2.
4 James Richards, Tate Shots, www.tate.og.uk/.../turner-prize-2014

Francis Bacon
Study for a Portrait 1953

Oil on canvas
198 × 137.5 cm

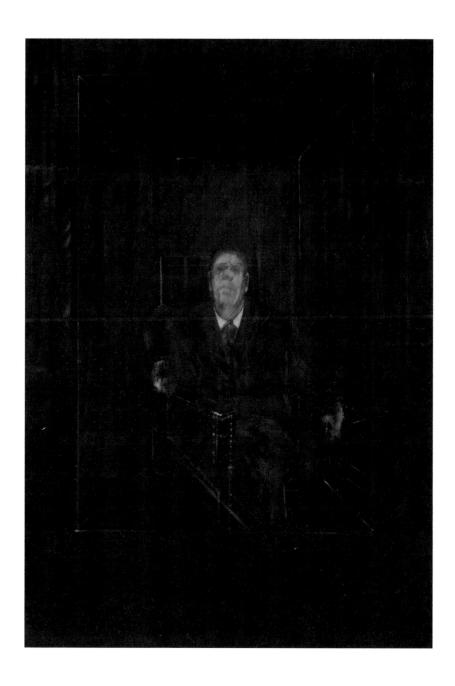

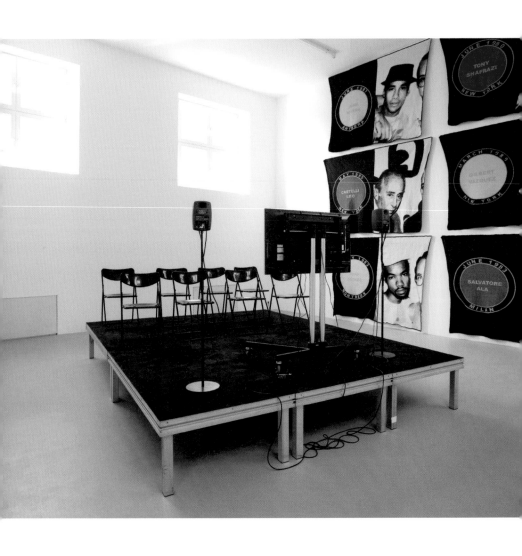

James Richards
Active Negative Programme 2008

Video, 17 minute loop, aluminium
platform, chairs, flat screen
Installation view: *The Imaginary Museum*,
Kunstverein München, Munich, 2012

To Replace a Minute's Silence
with a Minute's Applause

JAMES RICHARDS IN CONVERSATION WITH OMAR KHOLEIF

OMAR KHOLEIF: *Let's talk about your interest in curating and how it relates to your artistic practice.*

JAMES RICHARDS: For me, the primary artistic urge has always begun with collage, to convene materials in a way that produces something new, but also clearly shows the traces and edges of each constituent part. Working with video and sampling sound at art school, I gravitated towards LUX, an organisation dedicated to Artists' Moving Image in London and the film programmes curated by Stuart Comer at Tate and the late Ian White here at the Whitechapel Gallery. I started thinking about film programming as a kind of composition, and about applying the logic of rhythm, shifts in tension and texture, and suspense that I had been using to assemble found footage but now utilised to arrange screenings of artists' video. Some of these projects became installations, such as the *Active Negative Programme* – part of *Nought to Sixty* at the ICA in London in 2008 – which is a work that places an edited mix of videos loaned from the LUX archive intercut with my own footage and mounted on a conference platform. More recently I've been curating group exhibitions as well as screenings,

for example, *If not Always Permanently, Memorably* (2013) at Spike Island in Bristol and *Alms for the Birds* (2014) at Cabinet Gallery in London. I see this all as a continuation of the same process and artistic urge as my more authored works, which is to assemble and to allow a kind of associative play between very discreet materials, but somehow to set up enough tension and overlap to create a singular experience for the viewer.

OK: *You've mentioned that these processes are manifest in two different ways. Your video work, which often involves appropriated footage, incorporating materials that you have dug out of archives for which you compose audio work, but there is also a practice of exhibition making. How do you create distinctions between these two sets of experiences?*

JR: I am driven by a desire to interact with and manipulate things that fascinate me and with the process of framing them with other elements. This raises the question: why make a distinction between these practices?, when practically, I don't. The answer probably has to do with responsibility. If a material has been drawn from a distant enough context, such as mainstream cinema or

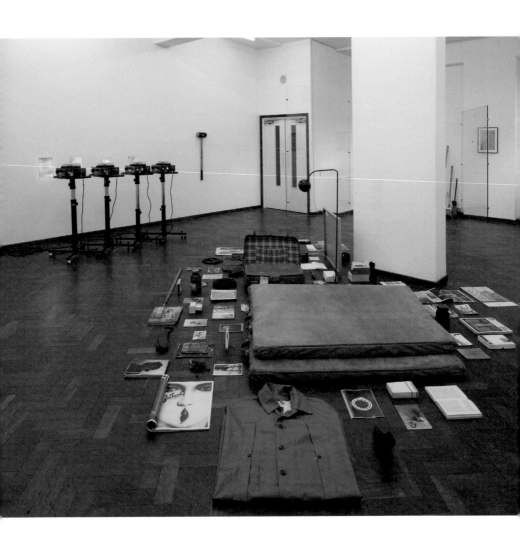

Installation views: *Alms for the Birds*,
curated by James Richards, Cabinet
Gallery, London, 2014

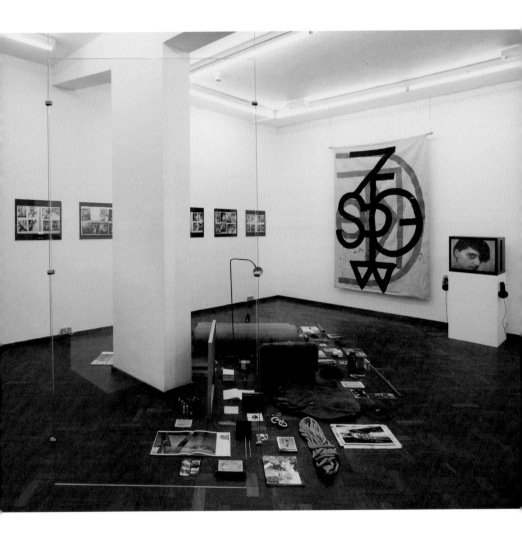

an anonymous clip found on YouTube, it probably feels more available for manipulation. It emerges differently from showing artworks in an exhibition... artworks that are selected because they feel resolved and [therefore] demand less alteration, and closer to the context in which I work. This sense of responsibility is very much tied to the notion of curating as 'caring for' – in the traditional sense of a curator being a custodian of art – and indeed the curatorial projects tend more towards a kind of embedding and convening, while the videos present material that has been subjected to a kind of violence, of remastering and remixing.

Another key difference is pragmatic; the way one ends up working on a project and the kind of immersion that is required. The videos come out of a very hermetic space where I am working alone and following intuition – building up material and feeling out a form for the work. I tend not to be able to speak so much about these works or their processes. Curating for me is much more about dialogues, reacting to settings, learning about works or areas of work that I want to find out about and working with the space and setting. My invitations to undertake such projects are less frequent and the rhythms different.

OK: *I find something in your work that is about a quest for a kind of purity. You often find things and strip them back, either through a process of dematerialisation or accentuation. I think this is a really nice segue into thinking about the V-A-C exhibition because what you have decided to do is strip back the logic of curating, in a*

way, to go for just one work. I think there's a kind of purity in that gesture.

JR: This project has been unusual, as instead of the choice of works stemming from research and attempting to get access to them as loans, which would usually be the case, here the available works and access to them is already given – that is, coming from V-A-C collection and sent as pdfs with notes on availability and exact dimensions – so somehow, immediately, the challenge is more to think experimentally about display and exhibition formats. Instead of a group show, I wanted to be very adamant and to exhibit, perhaps, the single most iconic work in the collection – to try and put a painting in a room that sets up a situation shift or adds to its experience: a room, a painting and a scenario for a painting.

I've chosen not to combine works but to present a single piece and layer the experience with physical modifications to the space and incorporating piece of music that will play in the room simultaneously. Here, I want to keep the show fairly sparse and in some way singular so that people might stumble into this room and have a strange encounter with a single work by Francis Bacon.

OK: *Yes. You're questioning the experience that the object creates in the world.*

JR: Questioning, but also embellishing, riffing off. The thing about making an exhibition is that it's actually quite a formal process for me: What does the room need? What do the artworks that

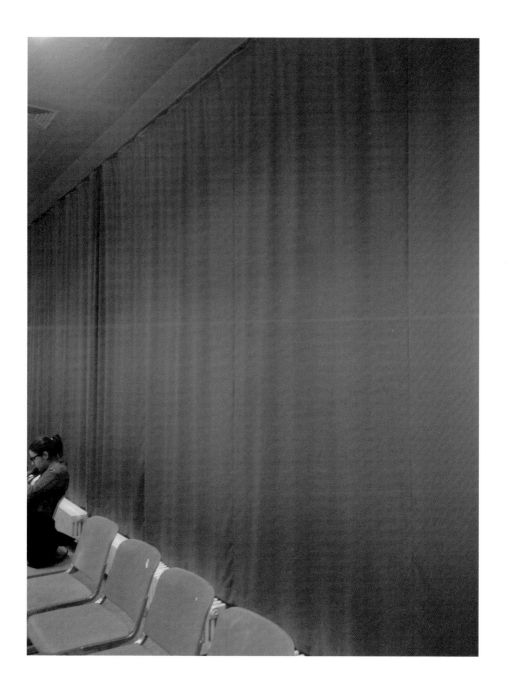

James Richards, research photograph
2015

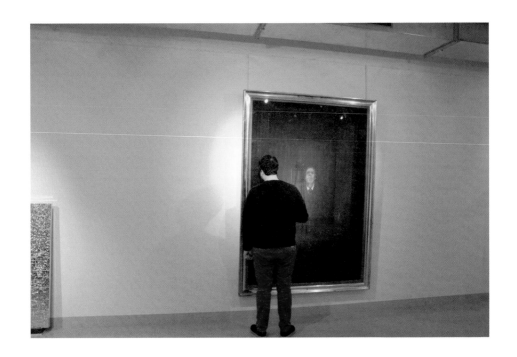

James Richards, research photograph
2015

we are showing require? I'm also using one element to trigger possibilities for other parallel and tangential experiences to be set up. I then utilise the authority of the gallery, the adamance of this room, to hold them together.

OK: *Let's consider the particular construction of this show.*

JR: My thoughts have gone through various configurations from the moment of invitation onwards, which continued to shift when I saw the list of works and then visited the collection's storage to see certain pieces in the flesh. I always had a sense that the project would focus on a single thing. It was an intuitive feeling. Early on, I also had the idea that I wanted to augment the environment with sound – to work with sound equipment and with the acoustic controlling apparatus of fabric panelling and carpet as a kind of architectural sculpture.

OK: *We had two scenarios, one with more collages or assembled material, but over time the singularity of the Francis Bacon work,* Study for a Portrait *(1953) emerged and configured our thinking. How did you begin to consider its architectural imagining in the space?*

JR: It's interesting to think about Bacon's work being about an individual in a room with no sense of being looked at from the outside. Instead it is a figure conceived from the inside. One can take this notion of the solitary figure conceiving of itself and use it as a point from which to build up some kind of projected inner voice. *Study for a Portrait* presents us with a figure

sat in a thinly-painted chair and set within a rectangle of colour that floats in the canvas. There is a sense of framing, and solidity and a kind of grand atmosphere surrounding the figure. He feels removed, embedded within the composition. The work has a singularity and pull, and also an immediately recognisable quality, which made it feel appropriate for this display.

This relates to my exhibition design for the show, which involves carpeting and isolating the space sonically with curtain-lined walls that flatten and deaden the acoustics... [to allow one] to think instead of stillness. This show, as such, becomes not a narration for the work now, but rather, a projection into the work, to produce new imaginings.

OK: *There is also a theatrical interplay between image and sound that takes place in the space.*

JR: For me, the way sound can both illustrate but also narrate makes it such a powerful tool. In the videos I make, I often move between passages of realistic sounds and completely overlaid sound that have no literal connection, but instead become a kind of interpretative tint for the material – colouring how it is registered and read. Somehow, now, I'm thinking of watching TV as a teenager with the sound turned off and an album playing and the way this set-up randomly shifts between the absurdist connections and disconnections that happen between the two separate streams. There's a kind of glee in the slipping in and out of connection between sound and image that I like working with.

James Richards' studio
The Block, London, 2015

OK: *As you have explained, there is an aural landscape in this installation. What are the sounds you are using?*

JR: I have been working with a number of different elements, for example, recordings of psychics who are claiming to be channeling dead composers from the afterlife. These are mostly piano parts, which I am manipulating and working with in the composition, and then there are also a whole bunch of recordings taken from videos of commemorative silences at the Cenotaph in London for the end of the First World War, or silences for recitals of John Cage's *4´33˝* (1952). Grand, already very weighty stuff I know, but I want to bring in a sense of anticipation and poise. I am interested here in communal silence and ritual. This concrete material is bedded with harmonic material from recordings I've made with Juice Vocal Ensemble, a trio of singers, with whom I've spent time in the recording studio, improvising around set melodies. The overall atmosphere is intended to be very vocal, oral – to ignite a pressing feeling of closeness of non-verbal communication. I'm looking to create a sense of clamminess in stark contrast to the set back stately figure in the painting, dressed in a pinstripe suit and enthroned in a papal chair.

OK: *Is it a corporeal experience?*

JR: It is in the sense that I'm working with a buzzy heady sound palette, all vocal overtones, slurs and mumbles. Also, it is intended to be a swarming presence – the 'other' presence in the room, which comes and goes around the painting.

OK: *You mean a maze-like experience, where the viewer is intended to be almost caged and disembodied?*

JR: Yes. I mean, relative to that, the entire object of the artwork. It is, in a sense, counter to being in a film ... you enter, and the sound in the space does not guide you but creates something moving around the room, pressing and flowing while the painting stands firmly in the centre. An immovable subject placed with a completely different temporal and sensory register. But, of course, of all subjects the bust of a person is so rife for projection and overlaid meaning. I am thinking a lot about anticipation and how the sonic element is not constant but rather begins and ends at set times, in contrast to the fixed quality of Bacon's study.

OK: *And so, this separateness is about silence but it's also about the amplification of experience, which ties into the title of the show,* To Replace a Minute's Silence with a Minute's Applause.

JR: Yes, my first thoughts were about working with the painting's singular and interior resonance, and then to ideas of anticipation and ceremony and how this gets marked sonically in ritual. This led me to the idea of communal silence: gathering to remember. When I started looking at the history of silence as a public event it led me to reading about silence in sports stadiums. Having a minute's silence of remembrance at sporting events was widespread for a long time, as a mark of honour for a sports man or woman that had died. However, over the last decade there has been a shift. So that in

James Richards, research photograph
2015

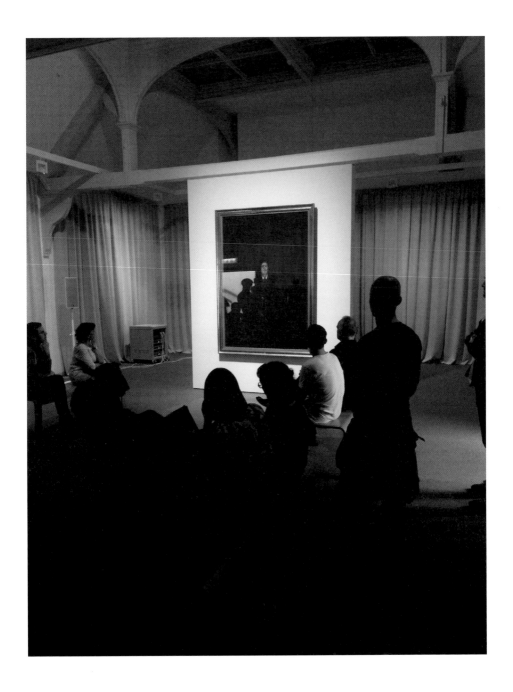

Installation view: *To Replace a Minute's
Silence with a Minute's Applause*,
Whitechapel Gallery, London, 2015

the 2000s, instead of trying to orchestrate communal silence in stadiums – which can be a problem to maintain as often fans of opposing teams would interrupt the silence with jeers – there was a move towards a minute's applause. As an image, the ceremonial cross-fade that took place in the conventions of mourning – from the pause of a crowd in silence to the more theatrical applause – feels apposite for the project we're working on here at the Whitechapel.

OK: *We've talked in the past about the idea of sonic wallpapering. Can you talk about some of the aural landscapes that have inspired or influenced you?*

JR: There was a show by Roberto Cuoghi called Šuillakku (2008) that I saw at the ICA when I was still a student; there were 16 audio speakers dotted around in a sound-panelled environment, and this very meticulous use of reconstructed sound. A kind of carnival of starkness, created the sense of an imaginative journey back to Mesopotamia in the sixth century BC, at the time of the ancient Assyrians. Because the room had nothing but the equipment in it, there was a sense of something dense but invisible just occupying gallery space and time, automating it. This really stayed with me.

There is a link back to this, as what I am creating here is a friction between two things – something animated and invisible and something visible and utterly still. I've been also having an ongoing conversation about the idea of exhibition music with writer and artist Gil Leung. Our discussion has been around ideas of

group show organising and extended to include the production of musak, radio play type content or working with the audio guide format.

OK: *At the beginning of our discussions about the show, you floated the idea of having two bodyguards straddling or securing the painting. Whatever happened to that?*

JR: It felt a bit too literal and heavy-handed, and too much about value. But it's playing [around] with things that I've continued to work with in the show, which I think don't need to be spelt out perhaps as much. For example, amplifying the singularity – amplifying or heightening the experience of the painting in a room.

OK: *Of drawing attention to the rarefied object.*

JR: Right, but also to play with the sense of encounter and the idea of the one-on-one encounter, or a charged encounter, is something I'm looking to manipulate and work with.

OK: *The idea of using ushers has now been replaced by constructing curtain-lined walls, which create a different kind of theatre. On another note, I am curious to ask, do you see the exhibition as a singular artwork?*

JR: Yes. I think it is – for the interest of conversation at least. The convening of all these things temporarily is an artwork. Then also, of course, the separate elements will continue to have other lives, invariably. and of course the painting will be shown in different exhibitions.

OK: *There is another reference that has been a real touchstone for this project.*

JR: Yes, particularly in terms of introducing duration into the exhibition, of something that is adamantly still. I've been obsessed with The Ardabil Carpet on display at the V&A Museum in London. I distinctly remember my first encounter with it while wandering through the museum. The carpet was made in the sixteenth century in Tabriz in Iran and because of its extreme fragility and sensitivity it is surrounded by a thick protective glass vitrine, which has a metal ceiling; the structure acts as a light and humidity control. Walking up to it, one encounters a very large dim glass cube that one peers and squints through to see a dark carpet in the gloom inside.

On the hour and at half past the hour an internal lighting system in the vitrine dimly illuminates the carpet, for ten minutes, before returning the carpet to its dimmer-protected state. I was really struck by the quiet theatre of this cycle: the hushed awe of something so delicate and old and absolutely still held in a cyclical self-illuminating display.

OK: *This brings me to a question about your practice. Most people see you as an artist who works with video, but actually I often refer to you as a composer because I think that there's a musicality to the way the images are composed. You've also told me that the way you often pull out images when listening to a piece of music or a piece of sound will sometimes dictate a rhythm for you, or a passion. How is this process governed, is it about form or structure, or is it an emotional process?*

JR: The composing of sound and images in a totally enmeshed room is the starting point. I have periods working with images, collecting and editing a bit, and then also periods with sound and music, making recordings, gathering samples and finding things that work together. The two things start coming together very quickly though, sometimes with the images being cut to rhythms of a passage of music, or vice versa. It's always a pleasure to try and make a realistic or correct-seeming soundtrack for an image, and to then disrupt it with something that acts more as a tangent or that introduces another contrasting atmosphere. I haven't had any formal music training, rather the process is something felt out.

In the case of this exhibition, because sound is the only temporal element in the show, I can allow the composition to find its own rhythm more. Here, we have mixed the sound in the space, across a number of speakers dotted around the room, placing *Study for a Portrait* in situ and reacting to the setting by composing a piece of music.

OK: *You're also setting up an atmosphere, something that elicits 70s Kubrick perhaps.*

JR: Yes! There is something intense happening in the convening of all the elements, both central and peripheral: from the colour of the drapes, white cables to the painting with its gold frame. I'm excited by what this interlocking produces and to then disrupt it and infect it with washes and pulses of sound.

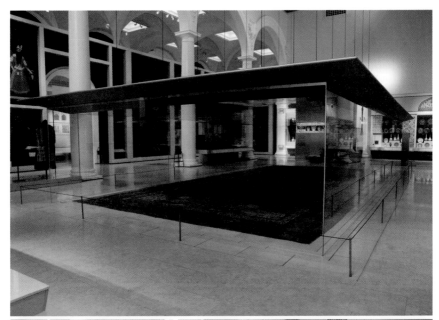

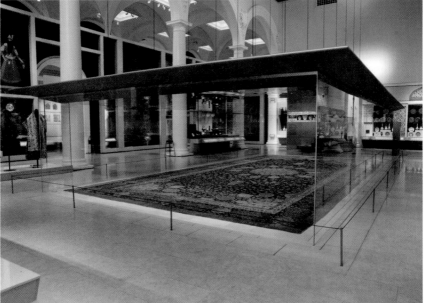

The Ardabil Carpet
Iran 1539-40. Hand knotted woollen
pile, on silk warp and weft; asymmetrical
knot - open to the left, 4,914 knots per sqm.

Display at the Victoria and Albert Museum,
London, with the case lights off (top) and
on (bottom)

overleaf:
James Richards, research photograph
2015

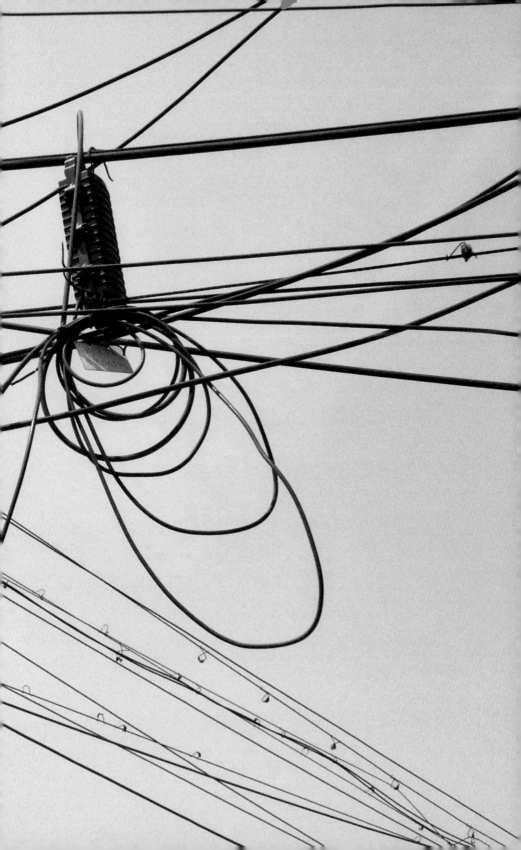

A Piercing Silence

DAVID TOOP

Sound is invisible stuff. Those who have expertise in its properties
and potentialities also have a tendency to lack a full understanding
of the worlds of tactile matter, visible surfaces, the volume of sound.
Sound is concurrently thing and no-thing, like air, money, time or
love, complex to infinitude as one of the ungraspable phantoms of
life. All these metaphors we use to bring into being the property
of sound and the sensation of its hearing: a honeyed voice, a rough
voice, a piercing scream; the taste of viscosity, a hand passes over
splintered wood, a needle punctures the skin. Think of the faintest
of sounds - that high sound of hearing, earing and air that we call
silence - pouring into the volume of a space, translucent block of
air like colourless jelly flecked and warped with every passing noise
event and its trail of decomposing matter, something like a stiff
liquid or intangible runny paste through which the body passes
without resistance yet it enfolds and penetrates the body with the
insistence of abyssal pressure and the clotted emotions of memories
as active entities, in flight like birds, insubstantial as papery moths.
Samuel Beckett wrote of this, in *Malone Dies* (1951):

> The noises, too, cries, steps, doors, murmurs, cease for whole
> days, their days. Then that silence of which, knowing what I
> know, I shall merely say that there is nothing, how shall I merely
> say, nothing negative about it. And softly my little space begins
> to throb again. You may say it is all in my head and that these
> eight, no six, these six planes that enclose me are of solid bone.
> But thence to conclude the head is mine, no, never. A kind of
> air circulates, I must have said so, and when all goes still I hear
> it beating against the walls and being beaten back by them. And

then somewhere in midspace other waves, other onslaughts, gather and break, whence I suppose the faint sound of aerial surf that is my silence.[1]

Within this skull that is the originary space from which we move out into the spaces of the world there is a teeming of inaudible, unverifiable sound that is indistinguishable from the self. A head in the darkness of a room, barely possessed of body, face jutting forward alert and listening to the air circulating, the monumentality of time articulated by these periodic vibrations we call sound. Of the heads of Francis Bacon, Gilles Deleuze spoke of them as an answer to the question posed by the history of art: 'How can one make invisible forces visible?', Deleuze wrote: 'The extraordinary agitation of these heads is derived from a movement that the series would supposedly reconstitute, but rather from the forces of pressure, dilation, contraction, flattening, and elongation that are exerted on the immobile head.'[2]

The immobile head looms, thrusts, seated in a darkness that may be absent of light or consciousness, convulsed by the rhythms of being, described by Henri Lefebvre as an integration of things: '...this wall, this table, these trees – in a dramatic becoming, in an ensemble full of meaning, transforming them no longer into diverse things, but into presences.'[3] Then there is a merging of presences, audible and inaudible, asking which is alive, which sounds are in the realm of the real, which are born airless from the inner hearing of the listener. 'If normal voice-hearing leads to the point that all experience is internal', writes Daniel B. Smith in *Muses, Madmen and Prophets* (2008), 'hallucinated voice-hearing begins there. Hallucinated voice-hearing conflates source and destination. All preliminary steps are bypassed. There is no breath, no manipulation of air, no movement of bones or cochlea, not even a stimulation of the auditory nerve. With voice-hearing the brain, working alone in its watery chamber, creates a voice out of nothing but its own duplicitous silence.'[4]

Can we ever be sure that sound exists (as a manipulation of air)? Rooms themselves have presence, resonate strangely in hypnotic

currents. In 1907, naval doctor, poet and theorist Victor Segalen, friend of composer Claude Debussy, wrote a small novel about this – *Dans un Monde Sonore* – in which the world of things becomes audible, the sense organs become interchangeably confused, sound can be crystal, light or an indeterminate uncanny resonance that renders speech indecipherable in much the same way that composer Alvin Lucier's *I am Sitting in a Room* (1969) gradually foregrounds resonance, obliterating writing and the sense of speech. Spaces breathe quietly to themselves, singing and whistling as if thinking in some ultra-dimension inaccessible to human perception. If one makes an audio recording of a room, the living force of it is immediately evident, not only its resonant frequency, its size, emptiness or fullness and reverberant characteristics but also the sound through which all of these auditory properties are translated into what we call atmosphere. This is the subliminal sublime; always acting upon the way we behave in any given place. It is part of the language of cinema. Film director David Lynch has said, 'I'm real fascinated by presences – what you call "room tone". It's the sound that you hear when there's silence, in between words and sentences. It's a tricky thing because in this seemingly kind of quiet sound, some feelings can be brought in, and a certain kind of picture of a bigger world can be made. And all those things are important to make that world.'5

Just as Segalen's protagonists in his *Dans un Monde Sonore* become gradually deaf to normal auditory conditions by their hypersensitive turn to the world of resonance, so Beckett's narrator in *Malone Dies* speaks of 'hearing things confusedly'; all those noises of the world that were once too easy to differentiate, he now hears as a 'single voice ... one vast continuous buzzing ... unbridled gibberish.'6 What he was once able to decompose into its component strands reverts into a composition of the world's sound. The human no longer plays an active part in its own theatre.

Within this domain of ambiguity and transference lies the potentiality for hearing what is seen; for seeing, tasting and touching what is heard. In mid-seventeenth-century Netherlands, the theatre of sound and listening in painting was dramatically

articulated by *An Eavesdropper With a Woman Scolding* (1655) by Dutch artist Nicolaes Maes. As a young man, Maes painted a series of six works in which the act of listening was represented by eavesdroppers overhearing mildly salacious scenes within domestic interiors. In this particular painting, a maid has left crockery in disarray in order to enjoy the sight and sound of her mistress giving a fearsome tongue-lashing to some hapless victim. On the right-hand side, a painted green curtain seemingly hung from a trompe l'oeil pole is pulled back to reveal half the drama, obscuring the view of the interior and concealing the victim. The painting's theme and treatment has its origins in Dutch farces for the stage, and even further back to Greek myth, to a contest between two artists and their facility with illusions. Zeuxis had painted grapes that were so lifelike the birds tried to eat them. Zeuxis then asked his contemporary Parrhasius of Ephesus to pull back the curtain so that he could see his rival's work, not realising that what he mistook for a curtain was Parrhasius's painting of a curtain.

Museums and galleries are ritual sites, theatres in which all extraneous stimuli and invisible forces, particularly sounds, are spirited away by the thought magic of museology and its suspensions of reality. Sound - noisy chatter, music, mobile phones and other distractions - are implicitly forbidden by unspoken rules of acceptable behaviour, though official lectures and gallery tours, teaching, audio guides and the noises of infrastructural machinery such as air conditioning and projectors are not. Within the frame is what matters, even though the frame, the enforcement of silence, the light, the colour of the walls and the constant presence of security are equally prevalent.

In the Kunsthistorische Museum in Vienna I sat contemplating Jan Vermeer's *The Art of Painting* (1665–68), considering the trumpet held by the woman who models for Vermeer's painter, its bell half concealed by the heavy curtain draped at the 'front' of the scene. A man sat next to me, German language audio guide spilling from his headphones in ethereal whispers that could have emanated from the painting itself. He stood, ostentatiously walked back and forth to study the still atmosphere of the painting and its silent trumpet,

the percussion of his shoes on the hard floor not at all silent or still. At Buckingham Palace I stood in front of *The Listening Housewife* (1656) by Nicolaes Maes, acutely conscious of maids whispering in adjacent rooms. In Dublin I walked through the National Gallery, my boots echoing from the wooden floors within their resonant halls, just as Samuel Beckett's boots echoed many years before. Again in Dublin, at The Hugh Lane Gallery I peered through glass at the painstakingly reconstituted wreckage of Francis Bacon's studio, thinking it not dissimilar to the authenticism of displays in contemporary zoos in which a small patch of desert sand is littered with location-appropriate cans and bottles. Somewhere behind hides a venomous reptile.

Buried within these involuntary scenographic, sarcophagic halls of antiquity is the compulsion to build narratives from incomplete (silent) images. Yet they are not so silent. Bacon, as Deleuze noted, wanted to 'paint the scream more than the horror'[7] (as he further notes, the sensation rather than the spectacle). Mouth closed, the man is alone in darkness, like so many other men scrutinised by Bacon, half-in half-out of indeterminate masculine haunts of club, study, bar or dungeon – suit, tie, white shirt, studded chair, claustrophobic frame – its murky truncated depths a seething murmuration of creaks, air, the apparatus and effects of respiration, black resonance at the threshold of hearing. This is what we call silence, a silence both unhearable and unspeakable. Unbearable too, the kind of silence heard or not heard in recordings of memorial silences bounded by durational markers, those one-minute silences in which life is held in abeyance for the sake of those who can no longer hear them.

In these silent haunts, spaces and gaps, sound is a haunting, a spectral presence that moves ghostly and unseen through every orifice and volume. Sound is an absent presence; silence is a present absence, a sinister resonance that forces us to question our belief in the things of this world. Francis Bacon spoke about opening up the valves of sensation, as if all the separated channels and reservoirs of the body could join their various intensities, all ingress and outflow mixing together in a hallucinogenic stream (or scream).

Any student of cinema or user of YouTube knows the dramatic effect of adding sound to images, manipulating sound already associated with images (those shred videos) or subtracting sound from images. For an example, imagine swapping Polish composer Krzysztof Penderecki's *Als Jakob erwachte* (1974), used by Stanley Kubrick for climactic scenes in *The Shining* (1980), with Mantovani's 'Colors Of My Life', used by David Lynch for *Inland Empire* (2006) – thinking of the shift between Kubrick's beautifully composed interiors and the lurching fuzzy flatness of Lynch's digital video – or imagine swapping Penderecki's *Als Jakob erwachte*, used by Lynch for *Inland Empire*, with 'Midnight, the Stars and You' (1934) by Ray Noble and his Orchestra, used by Stanley Kubrick for *The Shining*. But the music also changes according to the images; Mantovani's unearthly easy listening strings no longer easy, in Lynch's world overloaded with an ominous emotional tangle of tragedy and bliss.

Bring together painting and sound and two inimical theories of time confront each other. In one, the gaze claims no set duration; nothing moves under its scrutiny; its potential is to last for ever or be instantaneous, a fleeting glance. In the other, time and its complex rhythms are in a state of constant movement and unfolding. Space also shifts, the gaze of listening in motion everywhere. A piercing silence hangs in the air, lasting for all eternity or no time at all.

1 Samuel Beckett, *Malone Dies*, Penguin Books, London, 1977, p.59.
2 Gilles Deleuze, *Francis Bacon*, Continuum, London and New York, NY, 2005, pp.41–42.
3 Henri Lefebvre, *Rhythmanalysis: Space, Time and Everyday Life*, Continuum, London and New York, NY, 2005, p.23.
4 Daniel B. Smith, *Muses, Madmen and Prophets: Hearing Voices and the Borders of Sanity*, Penguin Books, New York, NY and London, 2008, p.21.
5 David Lynch and Chris Rodley (ed.) *Lynch on Lynch*, Faber & Faber, London, 1997, pp.72–73.
6 Samuel Beckett, *op.cit.*, pp.40–41.
7 Gilles Deleuze, *op.cit.*, p.43.

James Richards selects from the V-A-C collection:
To Replace a Minute's Silence with a Minute's Applause

23 June – 30 August 2015
Whitechapel Gallery, London, UK

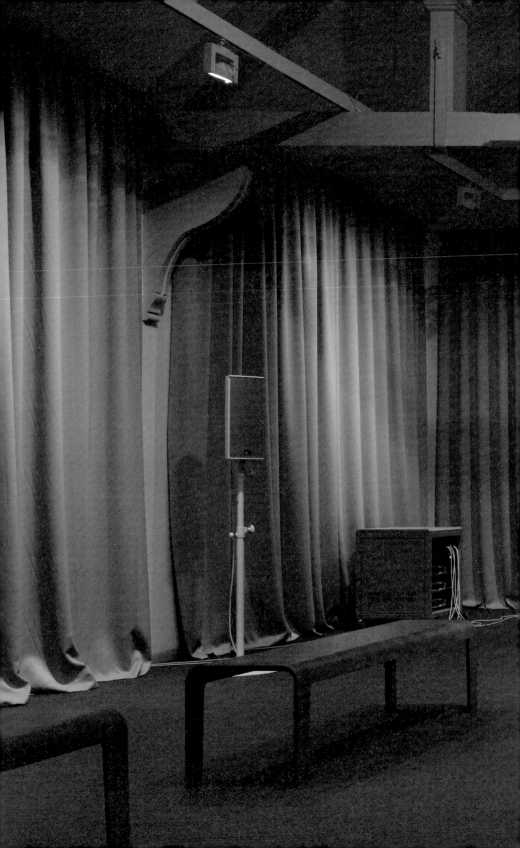

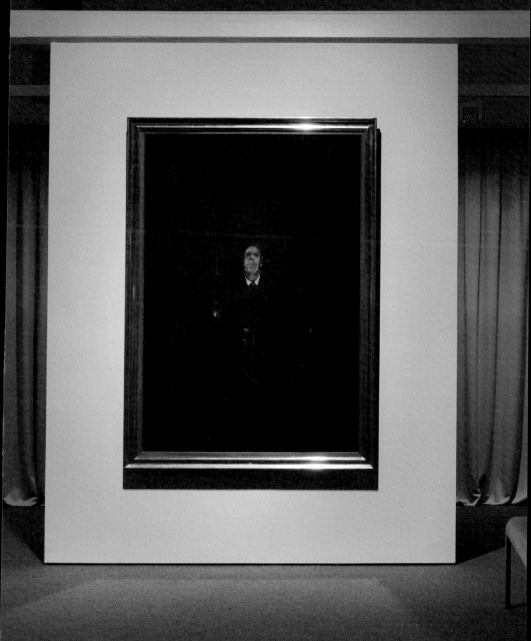

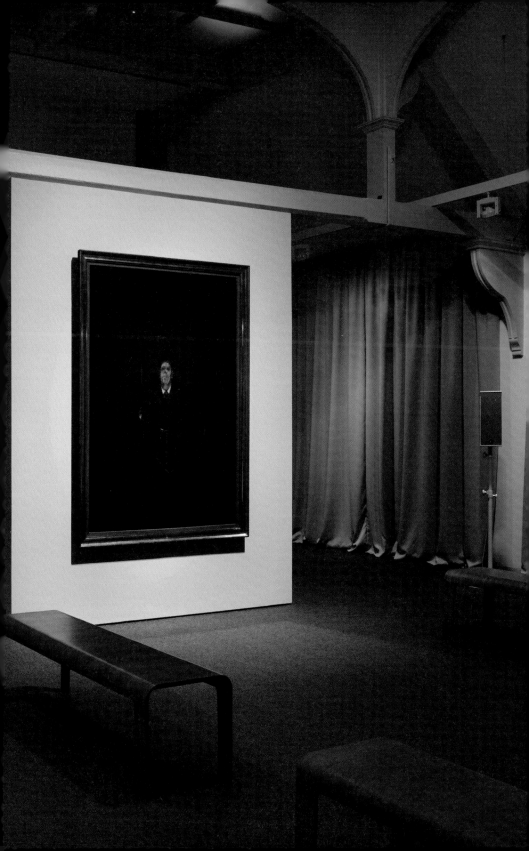

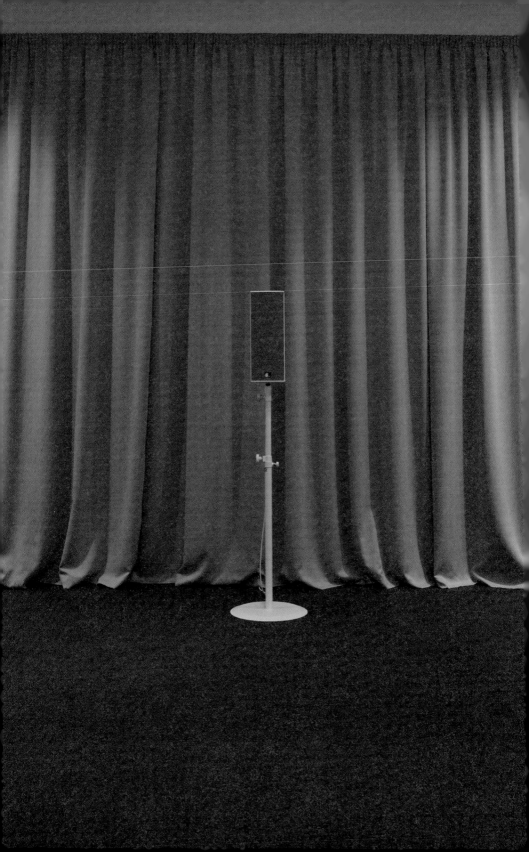

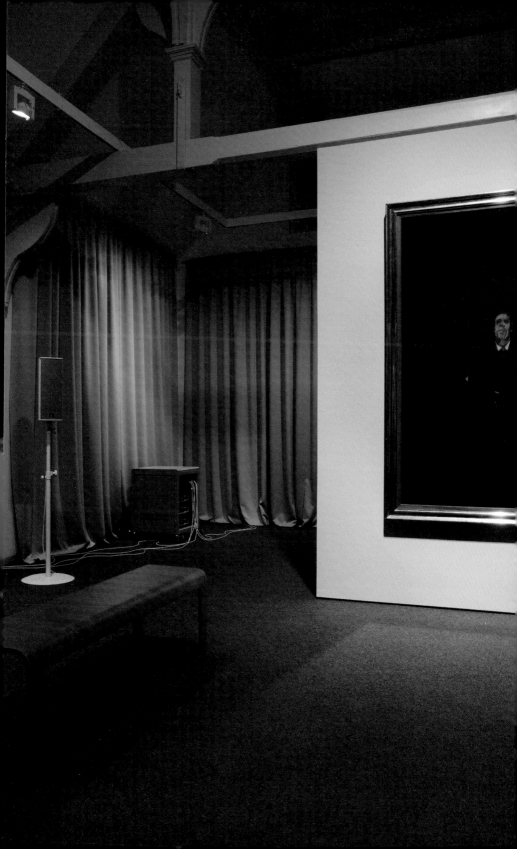

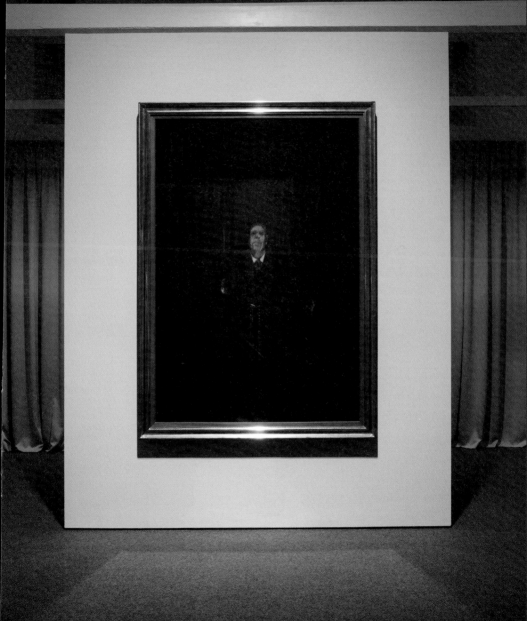

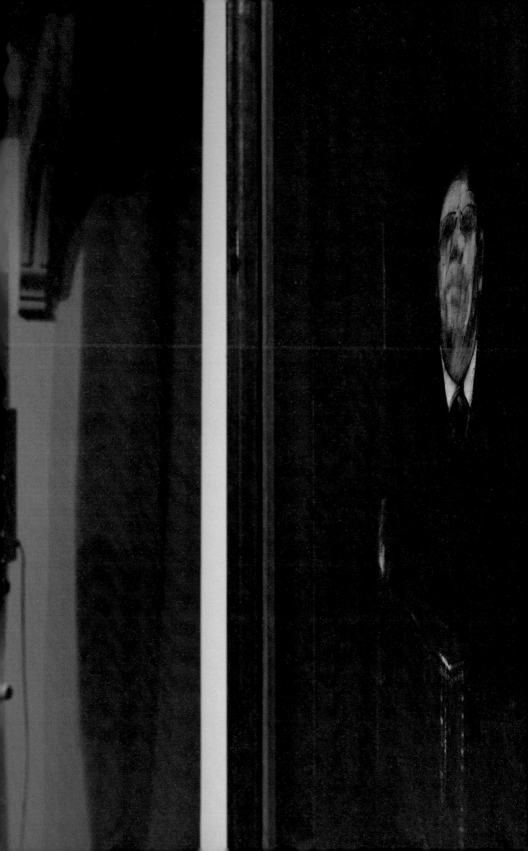

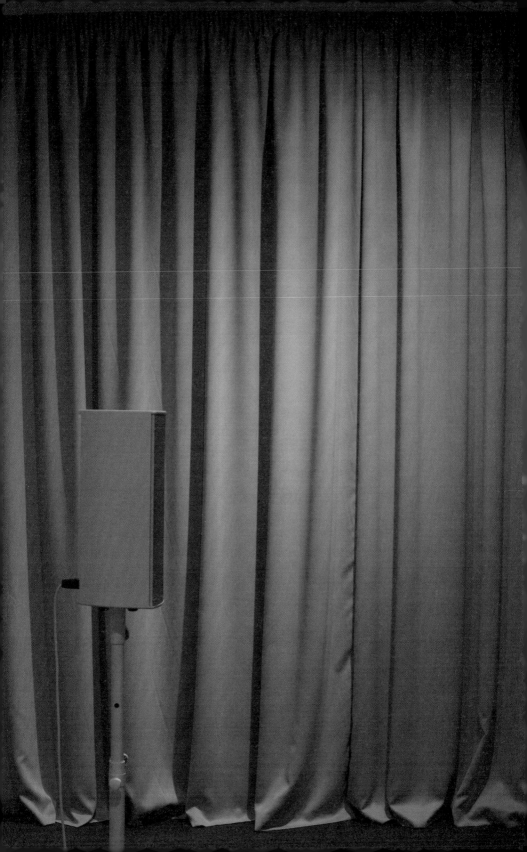

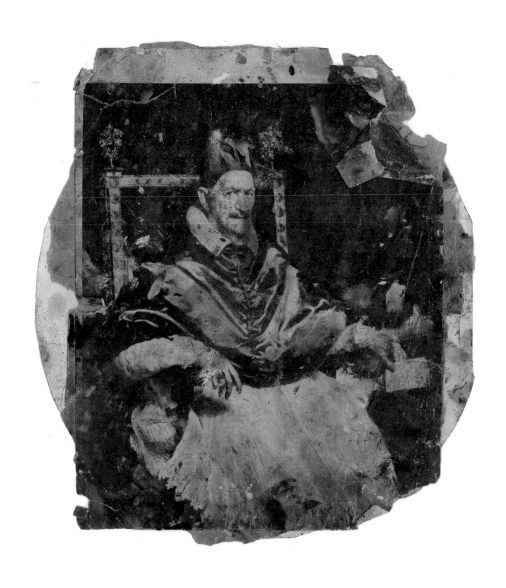

Manipulated illustration of Pope
Innocent X by Velázquez

Francis Bacon's *Study for a Portrait* (1953)

BARBARA DAWSON

Francis Bacon's early career as an artist saw him enjoy fitful periods of creativity countered by long bouts of inactivity. A self-taught artist he was, as he said himself, a late starter. When asked why, he replied that he didn't have a real subject. 'It is through my life and knowing other people that a subject has really grown.'[1] The subject is the human figure stripped of artifice and portrayed in images which are as beautiful as they are disturbing.

'A picture should be a re-creation of an event rather than an illustration of an object; but there is no tension in the picture unless there is the struggle with the object',[2] Bacon commented in the early 1950s. He sought a realism that went beyond simple representation or illustration. He wrestled with his subject matter, waging war on it, creating distortions and deformities in an attempt to create a new reality. In the words of Vincent van Gogh, an artist Bacon very much admired, he longed 'to learn to make those very incorrectnesses, those deviations, those changes in reality so that they may become, yes lies if you like but truer than the literal truth'.[3]

As the 1950s approached the stars were coming into alignment for Francis Bacon, but it was a turbulent period. Indeed the whole of Bacon's life was marked by peaks of high drama that found outlet in his work. Following on from the death in 1951 of his beloved nanny Jessie Lightfoot, who had lived with him in his studio at 7 Cromwell Place, South Kensington in London, Bacon gave up the studio he had lived and worked in since 1943. For a while he lived a nomadic existence moving from studio to studio until he moved into 7 Reece Mews, sw7 in 1961. But this did not affect his creativity and the early 1950s was a rich period of production for him. Undeterred by the reaction to his work, which was both critically

acclaimed as well as fiercely criticised,[4] Bacon continued his ruthless pursuit of his extraordinary imagery born out of his desire to capture the elemental nature of mankind; the essence of being devoid of its camouflage: 'We nearly always live through screens – a screened existence ... and perhaps I have from time to time been able to clear away one or two of the veils or screens.'[5]

His work produced from the mid 1940s onwards, including the spectacular and harrowing triptych, *Three Studies for Figures at the Base of a Crucifixion* (1944), confirmed the concerns that would dominate his work for the rest of his career – the tragedy of existence wrought out of an 'exhilarated despair'. This theme took many formats, and in the decade after his exhibition in the Hanover Gallery, London in 1949, his work concentrated on an isolated being in a state of anxiety and distress caged in an airless environment. It included single works as well as series including his famous 'Pope' series of 1953 based on the image of *Portrait of Pope Innocent X* (c.1650) by Velázquez; a portrayal of vast temporal power cloaked in religious hegemony. Bacon believed it to be one of the greatest portraits ever made. He was obsessed with it up until the mid 1950s and even after that it made periodic reoccurrences in his work. Velázquez's ability to both record an event and at the same time imbue it with the deepest of sensations greatly influenced Bacon and the compositional structure of a man seated in the foreground of the picture plane draped by a curtain-like background appeared in many guises in Bacon's work over the next decade. He was known to return to subject matter that has influenced him in earlier work and despite that his obsession with this subject was more or less over by the time he moved into Reece Mews at the beginning of the 1960s; several loose leaves containing illustrations of Pope Innocent X were found at the studio, as well as nine books on the Velázquez, suggesting an ongoing dialogue with this artist.

In Bacon's portraits of the Popes, the Pontiff seated on a gilded throne is tragically shorn of his power and veneer of civilization. His anxiety is palpable as he peers out at the viewer from his cage. In a state of crisis, frequently emitting a primeval scream, the image underpinning Bacon's brutal premise that man is animal –

Photograph of Francis Bacon's Studio
before its removal to the Hugh Lane
Gallery, Dublin

FEMME COUPÉE EN MORCEAUX (AFFAIRE DE MEKNÈS)
Collection du Dr Locard (Laboratoire de Police de Lyon).

Image of a dismembered woman
Le Crapouillot, May 1938

sharing the same basic instincts, reactions and behaviour – and this assertion drove him to create, in textured and sumptuous paint, some of the most memorable images in the history of figurative art.

Bacon sought inspiration for his images from a voluminous and diverse range of sources as the wealth of material from his studio at the Hugh Lane Gallery, Dublin reveals.[6] More than 500 books and 1300 loose leaves from books on subjects as varied as sport, medicine, cinema, animals and wildlife, art, artists, the photography of Eadweard Muybridge and paranormal phenomena were discovered in his studio, as well hundreds of photographs in various stages of destruction – these photographs were often torn, folded and creased.[7] Photojournalism, aided by the advent of the miniature camera capturing sensational and frequently violent world events with a detached immediacy as found in illustrated magazines, was another rich source of imagery for the artist.[8] It was, however, his own experiences and acute observations of the world around him that informed the nature and content of his source material.

Bacon sought to achieve a sensation of spontaneity and immediacy in his monumental images. He speaks of the 'trapping' of an image, that moment of chance or accident when the paint transforms into image almost of its own accord and which he selects to preserve. He sought for images to have independence so as 'they can unlock or shock the valves of feeling and return the onlooker to life more violently.[9]

Bacon lived through violent times. 'The times through which I have lived I don't want to ignore. They are part of the very texture of my existence.'[10]

At the outbreak of the First World War, he and his family moved from Ireland to London where his father Captain Eddy Bacon worked in the Army Record Office. Returning to Ireland he experienced first-hand the Irish War of Independence and the Civil War and later on during the Second World War, he witnessed the Blitz in London, harsh winters and severe food rationing. Seeing London ripped apart with gaping holes in iconic buildings and people killed and maimed put pressure on the nervous system.

'There were the lights – but there were also the dark streets,

streets where suddenly a house of blackness collapsed with a roar, shifting down heavily liked some bricked elephant lumbering to its knees, then into the torchlight of the wardens there would stagger those entrapped lonely figures in the dust-fog bleached grey with powder and streaked and patched with black blood.'[11]

Bacon escaped the grimness of postwar London when he visited South Africa in 1950 and again in 1952 to visit his mother who had settled there after Captain Bacon died in 1940 and where his sister Ianthe Knott lived. In a letter to Erica Brausen, director of the Hanover Gallery, dated 22 February 1951 he writes, 'I feel 20 years younger – we are mad to stay in England.'[12] Visiting the National Kruger Park in the 1950s allowed a proximity to wildlife, including lions, who could be found walking along the side of the road, which is no longer possible to experience. The beauty and muscular grace, the texture of skin and facial expression of these wild animals captivated Bacon, as too did their lightning predatory nature. He maintained a lifelong fascination with animals, zoology and birdlife as the books in his studio testify, suggesting they informed the treatment of flesh, movement and expression in his complex humanoid images. Among the earliest loose leaves on this subject matter found in the studio are black-and-white images from Marius Maxwell's publication *Stalking Big Game With a Camera in Equatorial Africa* (1924) and A. Radclyffe Dugmore's *Camera Adventures in the African Wilds* (1910). Later, in the mid 1960s, after he met wildlife photographer Peter Beard, Bacon speaks of the beauty of Beard's photographs of decomposing elephants – the result of a disastrous conservation effort. He found the chaos recorded in the images a release action that triggered sensations. 'After all, the mind tends always to make order out of chaos, patterns themes, so when it's brought back to the sort of chaos of decomposing elephants, the mind for a moment is taken off...and all kinds of other imagery enter, suggestions enter.'[13]

Bacon worked in deeply ordered chaos. In 1953 with his first exhibition in the United States set for the end of the year with Dulacher Brothers in New York, as well as an exhibition at the Beaux Arts Gallery in London, critic David Sylvester recalled Bacon

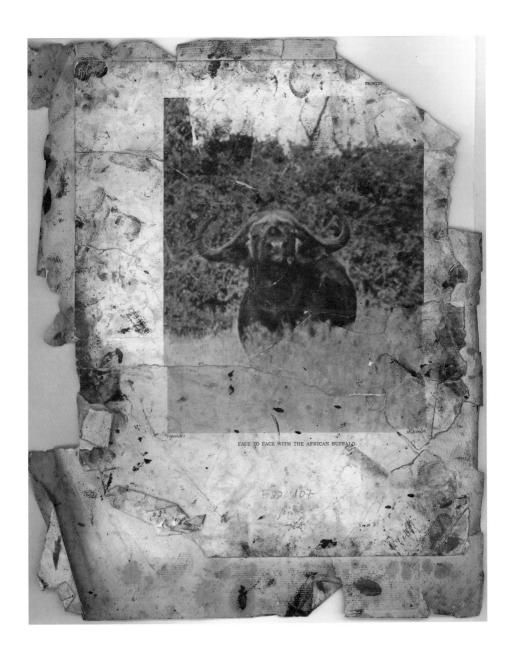

'Face to Face with The African Buffalo.'

Loose leaf from Marius Maxwell, *Stalking Big Game With a Camera in Equatorial Africa* (William Heinemann, London, 1924)

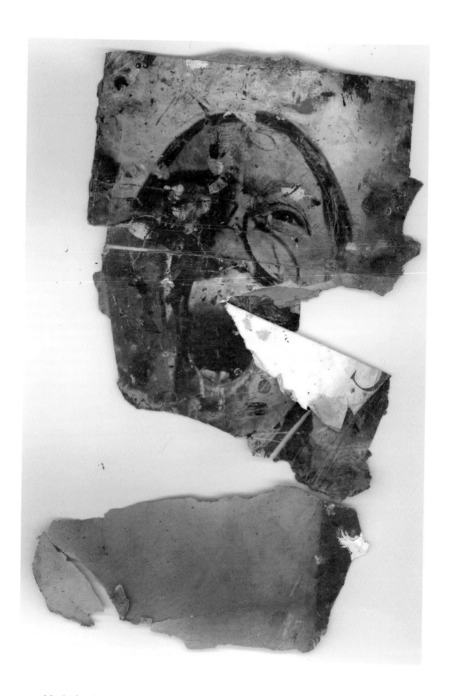

Manipulated illustration of the
screaming nurse in the Odessa Sequence
of *Battleship Potemkin* by Sergei Eisenstein

'was painting hard but he was destroying practically everything'.[14] Despite the chaos and the rush to get finished, it was a vintage year for Bacon.[15] Twenty extant paintings revealing a diversity of subject matter from dogs, baboon, sphinxes, a series of eight Pope paintings and portrait studies were produced, including *Study for a Portrait*.

Study for a Portrait was painted in the autumn of 1953, and was the last work Bacon painted in Rodrigo Moynihan's studio at the Royal College of Art, which Moynihan had lent him from 1951 to 1953. The subject suggests the forthcoming 'Man in Blue' series while the compositional structure of an imposing figure seated on a chair in an anonymous isolated space references Bacon's 'Pope' series.

A sense of drama prevails as the large stocky figure is seated centre stage in a dark, dramatic and evenly lit environment, casting no shadows. The male figure is framed in a box-like structure within an outer frame – a compositional device that both isolates and suggests depth. The fluid handling of paint in the outer area reveals layers of grey striations which give way to inky blue variations in the inner chamber. The chair is a cut-down version of a papal throne without the finials. A suggestion of gilt appears in the dabs of gold along the armrest and down the leg of the chair. The bright fleshy impasto of the man's face looms out of the shadows in a soft menacing manner and the blurred features suggest movement as if caught in a film still.

Bacon loved the cinema and was deeply influenced by the dramatic effects created by the medium; 'I would have made films if I hadn't been a painter.'[16]

One of the film directors who greatly influenced him in the 1950s was the renowned Russian director Sergei Eisenstein. Eisenstein's use of montage, a series of short shots edited into a sequence to condense space, time and information, was central to his filmmaking. One scene from his film *Battleship Potemkin* (1925) depicting the mutiny by the Russian navy in 1905 made a lasting impression on Bacon. The Odessa Steps sequence shows a nurse caught in the crossfire shot through her right eye shattering her pince-nez. With blood dripping down her face her mouth opens in

a silent scream. A much-manipulated black-and-white image of the nurse mounted on cardboard was discovered in the studio. Along with the multiple paint spatters on the image indicating Bacon consulted it while painting, he has painted in two black curved lines on the right side of the face emphasising the wounded eye.

Bacon harnesses this scream and the distinctive pince-nez in various compositional permutations in his paintings of 1953. In *Study for a Portrait* however, he deploys only the pince-nez and has silenced the scream. The protagonist's fleshy lips are closed and the sensual, if violent, elements of the mouth – the tongue, teeth and cry – are not in play.

In preparation for trapping his image on to the surface plane Bacon was alert to any means that might assist him: 'I think the difference between direct recording though a camera is that as an artist you have to, in a sense, trap the living fact alive.'[17] An innovation in widescreen projection, *This is Cinerama*^, was launched on Broadway, New York in September 1952.[18] The image is projected onto a deeply curved screen made up of over a thousand strips of material mounted on louvres like vertical venetian blinds. A leaf from the programme of the premiere of Cinerama was found in Bacon's studio. As was his practice, Bacon manipulated this found image by painting in a blue box-like structure around the image of a man in suit and tie, which is broken up by the overlapping vertical lines. The creased diagonal lines echo the diagonals in the space frame in *Study for a Portrait* and the vertical lines of screen material are echoed in the beautifully handled grisaille striations surrounding the seated figure.

The surrealist sculptures of Alberto Giacometti have been cited as another influence for Bacon's space frames. It is interesting to note however, that in Giacometti's *Portrait of Peter Watson*, which was also painted in 1953, Giacometti locks his sitter within a similar type of space frame as for *Study for a Portrait*, emphasising the melancholy of his friend and collector Peter Watson.[19]

Bacon's 'magisterial thug' however, is a commanding presence, poised between the image of a Renaissance prince and a blurred photograph. His demeanour suggests a pent-up energy supported

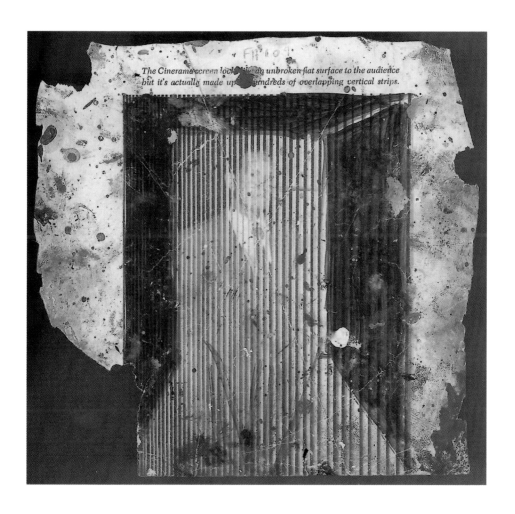

The Cinerama screen looks like an unbroken flat surface to the audience but it's actually made up of hundreds of overlapping vertical strips.

Leaf torn from the brochure for the premiere of *This is Cinerama*, September 1952

79

by the tension in his left arm. Although confined within his airless space, he is alert and waiting; the position of his arm suggests he could catapult himself out of his chair in a split second. He is both compelling and menacing; It is not certain who this sitter is, but it was most probably someone Bacon knew,[20] although it may also be an amalgamation of a few people, including the artist himself.

In his second interview with David Sylvester, Bacon speaks of the pictures of men in rooms as being of a person who is in a state of unease.[21] By 1952 Bacon had fallen in love with Peter Lacy, a good-looking Second World War veteran. It was a tempestuous and violent love affair, which was continued in Tangier over different periods from the mid 1950s until Lacy's death in 1962. Although the shape and features of the seated figure do not resemble Lacy, the brooding tension in the work may have been influenced by Bacon's lover. Bacon may also have been referencing himself. As the American writer Paul Bowles, who met Bacon in Tangier remarked, Bacon seemed 'like a man about to burst from internal pressures'. However, given the distinctive features of mouth and lips, it has been suggested the figure may be of David Sylvester, a staunch supporter, who together with art critic John Russell began to review Bacon's works regularly from 1952 onwards and who briefly shared accommodation with the artist at the end of 1953.[22]

This remarkable painting was given to Rodrigo Moynihan by Bacon, who subsequently sold it to the Irish artist Louis le Brocquy, who with his wife Anne Madden, knew Bacon well. In a letter to Bacon dated 16 May 1977 discussing his selling of *Study for a Portrait* Le Brocquy observes:

> [...] I have always known (and said) – even in the early fifties – that in the painting of our own time yours would be accepted among the greatest. Need I say I have pangs at the prospect of physically parting with [the] 1953 *Study for a Portrait*. But it has long ago become part of my subjective makeup and objectively it will in the end hold its own place quietly beside works by Tintoretto or Velázquez, for I believe it to be one of the most

economically resolved of your paintings as an astounding reconstitution of the human presence in paint [...][23]

In *Study for a Portrait* the commanding presence suggested by the sitter is annilated by the reality of his situation, enclosed in an airless space, vulnerable and ultimately defenceless against his fate.

1 David Sylvester, *The Brutality of Fact: Interviews with Francis Bacon*, Thames & Hudson, London, 1995, p.68.

2 Unpublished interview from 1952 by *Time* magazine, quoted in Andrew Carnduff Ritchie (ed.), *The New Decade: 22 European Painters and Sculptors*, exhibition catalogue, The Museum of Modern Art, New York, NY, 1955, p.60.

3 As quoted in Hugh Marlais Davies and Sally Yard, *Francis Bacon*, Abbeville Press, New York, NY, 1986, p.9.

4 Michael Peppiatt, *Francis Bacon: Studies for a Portrait*, Yale University Press, New Haven, CT and London, 2008, p.258.

5 David Sylvester, *op.cit.*, p.82.

6 There are over 7,000 items in Francis Bacon's archive at The Hugh Lane Gallery in Dublin. Bacon's studio and contents was presented to The Hugh Lane Gallery by John Edwards, the artist's heir, and Brian Clarke the executor of the Estate of Francis Bacon.

7 See Margarita Cappock, *Francis Bacon's Studio*, Merrell, London and New York, NY, 2005.

8 For a discussion on photojournalism in the late 1920s and 1930s see Martin Harrison, *In Camera: Francis Bacon, Photography, Film and the Practice of Painting*, Thames & Hudson, London, 2005, pp.83–88.

9 David Sylvester, *op.cit.*, p.17.

10 Richard Cork interview with Francis Bacon, BBC Radio 4, *Kaleidoscope*, 17 August 1991. Available at Dangerous Minds, http://dangerousminds.net/comments/Francis_bacons_last_interview_from_1991, accessed 18 June 2015.

11 William Samson, Westminster in War (1947), as quoted by Andrew Sinclair, *Francis Bacon His life and Violent Times*, Crown Publishers Inc. New York, NY, 1993, p.85.

12 As reproduced in Michael Peppiatt, *Francis Bacon in the 1950s*, Yale University Press and Sainsbury Centre for Visual Arts, New Haven, CT and London, and Norwich, 2009, p.144.

13 *Francis Bacon Recent Paintings 1968-1974*, exhibition catalogue, The Metropolitan Museum of Art, New York, NY, 1975, p.18.

14 John Rothenstein and Ronald Alley, *Francis Bacon*, Thames & Hudson, London, 1964, p.68.

15 David Sylvester, *Looking Back at Francis Bacon*, Thames & Hudson, London, 2000, p.78.

16 Richard Cork Interview with Francis Bacon BBC Radio 4, *Kaleidoscope*, 16 May 1985; 'A Man without Illusions'.

17 David Sylvester, *The Brutality of Fact, op.cit.*, p. 21.

18 Margarita Cappock, *op.cit.*, p.123.

19 See Adrian Clarke and Jeremy Dronfield, *Queer Saint*, John Blake Publishing, London, 2015, pp.293-94.

20 David Sylvester, *Francis Bacon in Dublin*, exhibition catalogue, The Hugh Lane Gallery, Dublin, 2000, p.65.

21 David Sylvester, *The Brutality of Fact, op.cit.*, p.48.

22 See Martin Harrison, *Study for a Portrait*, Christie's catalogue, 28 June 2011, lot 15.

23 The Hugh Lane Gallery Archive, correspondence with Francis Bacon presented by Louis le Brocquy and Anne Madden, 2001: LBCOPY3.

James Richards

James Richards assembles images and sounds to construct highly personal and expressive collages. His video works fuse found material with self-generated imagery and musical composition. Richards mines through easily available sources of moving image – be that online video, artists' films and feature films, or casual diaristic footage shot himself. The fragmented origins of each piece of footage are drawn together using rhythm, sound and movement to create a unified whole, and are accompanied by soundtracks composed by the artist. Richards is also active as a curator and has organised numerous screenings and exhibitions in Europe and the USA.

James Richards was born in Cardiff in 1983 and lives and works in Berlin. Solo shows include: *James Richards*, Kunstverein München, Munich (2015); *Raking Light*, Cabinet Gallery, London (2014); *Mercy Mercy Mercy*, DAAD Galerie, Berlin (curated by James Richards, 2014); *The Screens*, Rodeo, Istanbul (2013); and *Not Blacking Out, Just Turning the Lights Off*, Chisenhale Gallery, London (2011).

His work has been shown in many group exhibitions including *Aleksandra Domanović, Yngve Holen and James Richards*: Ars Viva 2014/2015, Bonner Kunstverein, Bonn (2015) and Hamburger Kunsthalle, Hamburg (2014); Biennale of Moving Images 2014, Centre d'art contemporain, Geneva (2014); Turner Prize 2014, Tate Britain, London (2014); *Cut to Swipe*, MoMA, New York (2014); *Burning Down the House*, 10th Gwangju Biennale, Gwangju (2014); *The Encyclopaedic Palace*, 55th Venice Biennale, Venice (2013); *Frozen Lakes*, Artists Space, New York (2013); *Generational: Younger Than Jesus*, The New Museum, New York (2009); *Nought to Sixty*, ICA, London (2008). He is a recipient of the Ars Viva Prize (2014/15), The Paul Hamlyn Foundation Award for Artists (2014), DAAD Artist in Berlin Programme (2013-14) and the Derek Jarman Award (2012). He was shortlisted for the Turner Prize, 2014.

Iwona Blazwick

Iwona Blazwick OBE has been Director of the Whitechapel Gallery, London since 2001 and is a curator, critic and lecturer. She was formerly at Tate Modern, Institute of Contemporary Art in London and worked as an independent curator in Europe and Japan. Blazwick is series editor of *Documents of Contemporary Art*, co-published by the Whitechapel Gallery and The MIT Press. She has written monographs and articles on many contemporary artists and published extensively on themes and movements in modern and contemporary art, exhibition histories and art institutions.

She has served on many juries including the Kandinsky Prize; Turner Prize and the Venice Biennale Golden Lion award. She is Chair of the Max Mara Art Prize for Women and a jury member for the Jarman Artists' Film Award.

Iwona Blazwick is a Trustee of Harewood House in Yorkshire; and serves on the Advisory Boards of the Government Art Collection; the Paul Mellon Centre for British Art and the Trafalgar Square Fourth Plinth Commission. She was on the Advisory Board of *Documenta 13*; the *2015 Istanbul Biennale* and the MAXXI Museum in Rome; she is also Chair of the Mayor of London's Cultural Strategy Group.

Omar Kholeif

Omar Kholeif is a writer, curator and editor. He is currently Curator at the Whitechapel Gallery, Senior Editor of Ibraaz Publishing and Senior Visiting Curator at HOME. Previously he was Senior Visiting Curator at Cornerhouse, headed up Art and Technology at SPACE, London (where he was director of The White Building, London's centre for art and technology), and was Curator at FACT, Liverpool. Omar was also Artistic Director at the Arab British Centre, London and Founding Director of the UK's Arab Film Festival. Omar's work focuses on issues of narrative and territory in art. His recent publications include *You Are Here: Art After the Internet* (2014), *Jeddah Childhood circa 1994* (2014) and *Moving Image* (2015).He has curated major exhibitions internationally, including the Liverpool Biennial, the Cyprus Pavilion at the 56th Venice Biennale, the Abraaj Group Art Prize at Art Dubai, UAE, and Armory Focus: Middle East, North Africa and the Mediterranean at the Armory Show, New York.

Barbara Dawson

Barbara Dawson is Director of Dublin City Gallery The Hugh Lane, which was founded by Sir Hugh Lane in 1908. In 1998, Barbara Dawson secured the gift of Francis Bacon's Studio and Archive from the artist's heir John Edwards and executor of the Estate Brian Clarke and relocated it from London to Dublin where it opened to the public in 2001. She has curated several exhibitions including Francis Bacon, *A Terrible Beauty* (2009); Richard Tuttle, *Triumphs* (2010); Richard Hamilton and Rita Donagh, *Civil Rights Etc.* (2011) and Willie Doherty *Disturbance* (2011)

In 2006 Dawson oversaw the completion of the Gallery's new wing. She is a graduate of the MLI Getty Foundation Programme, was a member of the Board of Dublin Contemporary 2011 and is a member of the Public Art Advisory Committee for Dublin City Council. In 2010 she was awarded a PhD Fine Arts by the National University of Ireland and in 2014, she was appointed Adjunct Professor of The School of Art History and Critical Policy at University College Dublin. Barbara Dawson is currently part of the Advisory Committee for Dublin's Bid for European Cultural Capital 2020.

David Toop

David Toop is a composer/musician, author and curator based in London, who works across the fields of sound art and music. He has recorded Yanomami shamanism in Amazonas, Venezuela, appeared on Top of the Pops with The Flying Lizards, exhibited sound installations in Tokyo, Beijing and London's National Gallery, he has worked with artists ranging from Bob Cobbing and Ivor Cutler to Akio Suzuki and Max Eastley. Toop's published books include *Rap Attack* (1984), *Ocean of Sound* (1995) and *Sinister Resonance* (2010). Since his first album, released on Brian Eno's Obscure label in 1975, his solo albums include *Screen Ceremonies* (1995) and *Sound Body* (2007).

As a curator, Toop's exhibitions include *Sonic Boom*, Hayward Gallery, London (2000), *Playing John Cage*, Arnolfini, Bristol (2006) and *Blow Up*, Flat Time House, London (2010). His opera, *Star-shaped Biscuit*, was performed as an Aldeburgh Faster Than Sound project in 2012. He is Chair of Audio Culture and Improvisation at University of the Arts London, and is co-creator of Sculpture events with artist Rie Nakajima.

Acknowledgements

James Richards would like to thank Matt Fitts for his collaboration and support in the realization of this project.

Whitechapel Gallery
Behind the V-A-C collection are some visionary individuals, not least, its owner and President Leonid Mikhelson. Just as, a century ago, art patrons such as Pavel Tretyakov or Sergei Shchukin brought the most exciting art of their time to Moscow, so Leonid Mikhelson has brought to Russia, important modern and contemporary art from around the world. Like them, Mikhelson is also committed to supporting Russian artists, collecting and commissioning work. The V-A-C collection has evolved under the inspired stewardship of Director Teresa Iarocci Mavica. Increasing access and understanding of its many remarkable treasures is Helen Weaver who has reached out to a growing number of international partners. It is a testament to the V-A-C that they have given unlimited access to their remarkable holdings to four British artists, to the Whitechapel Gallery and to London audiences enabling new perspectives to unfold.

The Whitechapel Gallery's programme of collection displays is sponsored by Hiscox. Since its inception in 2009 this programme has attracted over a million visitors. We are grateful to Robert Hiscox and his team for their commitment to bringing great art to national and international audiences. This wider vision is also central to the work of Arts Council England who we are proud to count as the principal funder of the Whitechapel Gallery.

This collaboration between James Richards and the V-A-C collection has been underpinned by the curatorial work of my colleagues, Omar Kholeif, Habda Rashid, Christopher Aldgate and Patrick Lears; my thanks to them, and Rodeo Istanbul/London and Cabinet Gallery, London.

Our gratitude also to the contributing authors, Barbara Dawson and David Toop as well as designer Mark Thomson.

This book is one of four publications, each accompanying a display of works from the V-A-C collection curated by British artists who individually exemplify a specific medium. The four displays selected by, Mike Nelson, Fiona Banner, Lynette Yiadom-Boakye and James Richards, presenting together iconic works alongside undiscovered masterpieces from across the century, they transform curating into an act of creation.

Iwona Blazwick

Cherrill and Ian Scheer
Karen and Mark Smith
Bina and Philippe von Stauffenberg
Mr and Mrs Christoph Trestler
Audrey Wallrock
Kevin Walters
Susan Whiteley
and those who wish to remain anonymous

THE AMERICAN FRIENDS OF THE WHITECHAPEL
GALLERY
Dick and Betsy DeVos Family Foundation
and those who wish to remain anonymous

WHITECHAPEL GALLERY FIRST FUTURES
Phoebe Armstrong
Katharine Arnold
John L. Auerbach
Cedric Bardawil
Edouard Benveniste-Schuler
Fiorina Benveniste-Schuler
Natalia Blaskovicova
Amanda Bryan
Livia Carpeggiani
Ingrid Chen
Bianca Chu
Nathaniel Clark
Celia Davidson
Michael De Guzman
Alessandro Diotallevi
Olga Donskova
Michelle D'Souza
Will Elliott
Emilie Faure
Christopher Fields and Brendan Olley
Brett Frankle
Pujan Gandhi
Laura Ghazzaoui
Matt Glen
Lawrence van Hagen
Asli Hatipoglu
Dr Clare Heath
Hemmerle Contemporary GmbH & Co. KG
Katherine Holmgren
Anastasija Jevtovic
Sophie Kainradl
Zoe Karafylakis Sperling
Deborah Kattan
Robin Katz
Tamila Kerimova
Madeleine Kramer
Aliki Lampropoulos
Alexandra Lefort
Laetitia Lina
Xi Liu and Yi Luo
Julia Magee
Kristina McLean
Alexander Meurice

Janna Miller
Indi Oliver
Katharina Ottmann
Josephine von Perfall
Sonata Persson
Benjamin Phillips
Hannah Philp
Patricia Pratas
Maria Cruz Rashidan
Eugenio Re Rebaudengo
Daniela Sanchez
Paola Saracino Fendi
Elisabeth von Schwarzkopf
Silvia Sgualdini
Henrietta Shields
Marie-Anya Shriro
Max Silver
Tammy Smulders
Yassi Sohrabi
Alexander Stamatiadis
Joe Start
Louisa Strahl
Roxana Sursock Karam
Gerald Tan
Edward Tang
Billal Taright
Nayrouz Tatanaki
Coco Toepfer
Giacomo Vigliar
Claire Walsh
Alexandra Werner
Rosanna Widen
Fabrizio Zappaterra
and those who wish to remain anonymous

WHITECHAPEL GALLERY ASSOCIATES
John and Christina Chandris
Lyn Fuss
Chandrakant Patel
Karsten Schubert
and those who wish to remain anonymous

We remain grateful for the ongoing support
of Whitechapel Gallery Members.

The Whitechapel Gallery is proud to be
a National Portfolio Organisation of Arts
Council England.

Image Credits

Published in 2015 on the occasion of
the exhibition:

*To Replace a Minute's Silence with
a Minute's Applause*

23 June – 30 August 2015
Whitechapel Gallery
77–82 Whitechapel High Street
London E1 7QX
United Kingdom
whitechapelgallery.org

Exhibition:
Curator: Omar Kholeif
Assistant Curator: Habda Rashid
Head of Exhibitions Design and Production:
 Chris Aldgate
Gallery Manager: Patrick Lears
Installation coordinator: Will Clifford

Publication:
Editor: Omar Kholeif
Publication Coordinator: Habda Rashid
Designer: Mark Thomson
Copy Editor: Eileen Daly
Printed in Estonia by Tallinna
 Raamatutrükikoja OÜ

ISBN: 978-0-85488-2403

Published by Whitechapel Gallery, London
 and V-A-C Foundation, Moscow

First published 2015

© 2015 the authors, the artists,
the photographers, Whitechapel Gallery
Ventures Limited

Whitechapel Gallery is the imprint of
Whitechapel Gallery Ventures Limited

A full catalogue record for this book is
available from the British Library

To order call +44 (0)207 522 7888 or email
mailorder@whitechapelgallery.org

Distributed to the book trade by
Central Books
centralbooks.com

The editor and publisher gratefully
acknowledge the permission granted to
reproduce the copyright material in this
book. Every effort has been made to trace
copyright holders and to obtain their
permission for the use of copyright material.
The publisher apologises for any errors or
omissions and would be grateful if notified of
any corrections that should be incorporated
in future reprints or editions of this book.